MUSINGS OF A
WANDERING MINSTREL

Musings Of A Wandering Minstrel

A Collection of Musings in Poetic and Art Forms

Ravi Trivedy

PARTRIDGE

A Penguin Company

Partridge books may be ordered through booksellers or by contacting:

Partridge India
Penguin Books India Pvt.Ltd
11, Community Centre, Panchsheel Park, New Delhi 110017
India
www.partridgepublishing.com
Phone: 000.800.10062.62

Musing [**mju:zing**] (verb) – To think about something in a dreamy and abstracted way

Minstrels [**min**·strels] – medieval reciters of poetry, whose lyrics told stories of distant places, imaginary objects and events. Many minstrels were expelled from courts, usually for being offensive, and wandered about as raconteurs of tales, in public places. *Not all of them played the harp as accompaniment to their verse.*

If Galileo had said in verse that the world moved, the inquisition might have left him alone.

Thomas Hardy

A picture is a poem without words

Horace

For Roo

The world is yours, but you must want it

SONGS OF
LONGING

Another Day Passes By....

Strange day

mourning the passing of something abstract

unfathomed heartache

somewhere faraway

I awoke

felt no pain

then suddenly a distant siren call

a leaf trembled when you spoke

All things pass

entropy ensures that things will simmer

maybe there will be joy again

and yet, alas

a little dimmer

Roo

My arms around you

a bond with a child

she grows too fast

too tall for her old bed

a beautiful life ahead

Memories last

I remember you crawling

across my back

tickle of little paws

a description of something

only you understood

a smile melts any flaws

Always joy

a world of your own

days in orange

nights of lights

my wish that you don't grow

cannot be strange

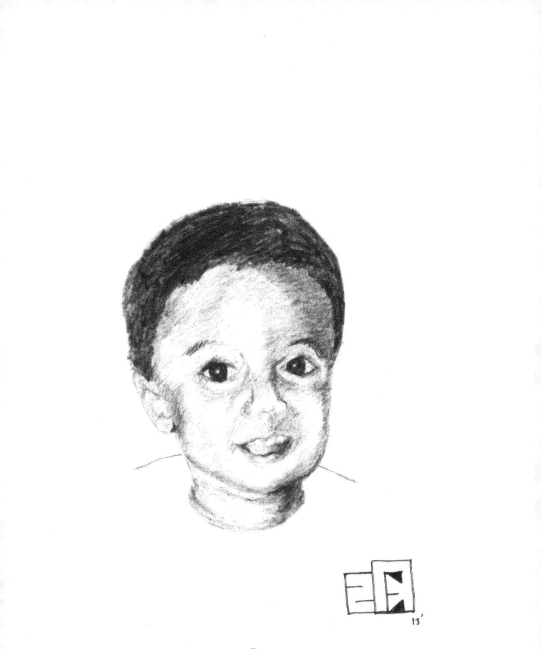

Roo

Cinderella's Dilemma

She reflects

as she stands at the doorway

unable to take that step

torn between the ghosts of the past

and the outstretched hand

of a hazy future

terror strikes at twelve

Cinderella has no choice but to run

I have the glass shoes

Faraway Losses

The great tree, many generations old

fell below the canopy of the dense green forest

The wilderness continued oblivious,

was the sound of the fall even heard?

For the scurrying creatures below,

it gave shelter, shade and solace.

Into its great giving bosom they would scramble,

if the world closed in around them.

Who will now envelop in its shroud of comfort,

the parrot, the squirrel, the snail and the mushroom,

now that the great tree is gone

In a remote corner of the universe, another star imploded

its memories sucked into a dark void,

not even beloved voices could escape.

Radio waves from this event,

were recorded as just another inter-stellar incident

by a faraway telescope on a hill.

Yet, for the small planets orbiting this sun,

it was the furnace that gave them warmth and light.

In the confluence of so many parabolic paths

its gravitational pull, promised them steady nights and days

The orbiters will soon crumble to dust

unfettered, lost in a light speed drift.

An angel died without any warning yesterday,

far away from where she was born.

A notice tucked away amongst the ads in the paper,

would mark her passing without a show of emotion.

To sweaty readers on the 8:24 train it did not merit a second glance.

Yet, to the small band left behind,

who needed a moral compass when lost in the desert,

in the stormiest ocean waves,

the port that sheltered the ship in a tempest, is gone.

Faraway Losses

Colors Combine

Until the blues and reds mingle

be tough to find a purple patch

one would always remain single

and the fortunes of two never match

Unless the sand and sky meet

a green forest will not emerge

and the steady fall of lonely feet

only be joined for a dirge

When white and black intertwine

the shades of gray define real

an edge stands out alpine

two ends joined make a seal

The Assassin

The young assassin steps towards his prey

all the while, twirling the dagger with which he will kill

the cold steel sharpened to a point, the jagged edges glinting

no tremors or jitters, reflection of a strong will

The neon sign proclaiming "salvation" burns its image into his mind

no symptom of emotion emerges from the depths of his being

only a calculated desire to destroy all that was once good

no moral dilemmas temper his thinking

Now there is darkness and he steps up the pace

the victim hears his approach and turns her face

moving swiftly he clasps her hair

he looks into her placid eyes and senses a dare

no plea for mercy, end the pain she implores

the sudden wetness as the dagger plunges in to her core

she is lifeless now, the deed committed

he feels no anguish and no guilt is permitted

The neon sign now blinks "love is the answer for you"

he stands vindicated, knowing that it's not true

A Life's Lament

Here we stand,

on the edge of forever

for me there may be no tomorrow

for us there may never be an ever

The Passing

The sun rose

in the eastern sky

a dash of blue

with a blaze of gold

you emerged

from a sea of serendipity

cool breeze

rushed over me

a desire felt

passes like a cloud

the sun set

in the western sky

the day

and a life

were over

A Traveler Grieves

Replay and edit.

not regrets, just options,

not chosen or seen.

Friends and selves,

left by the wayside.

Swept by tides,

of time and distance.

Had I seen you,

standing by the road,

we could have traveled

a few miles together

Yet no qualms.

Later not sooner,

our paths merge.

Bjorn, Why Did You Have To Go?

It's a dimming twilight, yet the battle continues

the final set is at 6-5, and the game is deuce

a forehand kisses the line's edge and the spectators gasped

they bow, and plead for a miracle, with hands clasped

like a phoenix rising, can he play like a champion again

at this match-point, can he dream beyond his pain

He stands bloodied, yet unbowed and proud

a titan of his times, the hero of the crowd

three bounces and the pretender's booming serve

deep in the backhand corner, the spin makes it curve

his return is wide, a life's match is done

he shakes a hand quietly, and walks off into the sun

Epitaph

I have a photograph

of a passing emotion

that painted your face

I wrote an epitaph

to a strange sensation

that ruffled your grace

Some Memories Remain Unruffled

The Lost Wanderer

A path in a desert

changes direction with every gust of wind

as sand blows over the footsteps

of a traveler before me

now I am lost forever

wonder if I will lead others astray

in a similar way

Soft Whispers

A diatribe.

Messages,

lost in volumes

absorbed,

with apathy and ire

A soft speak.

Propositions,

open a closed heart

inhaled,

like gasps of fresh air

Persistence of You

Picked up a shard of green glass

clouds,

like streaks of pealed laughter.

Reflections,

of a thousand images.

could swear,

every image had a bit of you

On the street, a broken neon sign

flashing,

subterranean messages of hope.

Changing,

words a thousand times.

Suddenly,

your name appeared in blue

On the television last night,

a channel of faith.

an electronic evangelist sang,

tunes

in praise of glories past.

every song,

seemed to mention you.

Persistence of YOU

Song of Loathing and Derision

Towards you, I will not display chivalry

I refuse to be humanely compassionate.

With your private demons, settle your own rivalry

I see your good is dead, perpetually lives the degenerate

I am not the doctor who will give you healing

Nor provide nirvana as your preacher

Find some glue, repair your own brain's ceiling

You, I have classified forever, as an unfixable bleater.

I give no shelter to your ship in the raging storm

When you capsize, I will not seek, nor rescue

May you be blinded by thirst and by scurvy, your limbs deform,

Lost forever, without hope, in the deep fescue

When you ache, from me, no balm or relief

In troubled times, by you, I will never stand

You I no longer trust, you abused my belief

Live in the mirror, as your friendships disband

At every turn, on you, I will heap abuse

When you cry, I will pull away my shoulder

In a lowbrow dive bar, go sing of your blues

May the sun shine on the world, but you turn colder

Do not seek me to be your white knight,

I will loathe playing your champion defender

Get bloodied and broken in your own fight,

May you show no courage, be the first to surrender

Put me back in the bog

You demand a prince,

I am contented as the frog

Smiling Phoenix

On a soaring thermal

paint the skies

diva phoenix

rise from the ashes

a beatific serenity

replaces the darkness

a smile opens the heavens

toes tap a dance

freedom is won

no fear in the shadows

a life interrupted

restarted again

A New Beginning

In the embers, a spark

found a reason to breathe.

woke up to an angel's smile

the demons of darkness

scatter at the approach

many things yet unsaid

await the emerging dawn

Temptation

A frightened sleep

you appear as a light beam

disturb the dark beyond

emerge as a shadow dream

a chance encounter

turns to dust

a moral turbulence

reduces to lust

the sound of laughter

disturbs a peace

attained in a cocoon

a mind on lease

The Devotee

Smiles melt,

the polar ice sheet.

the little crinkle,

age you blame.

See yourself,

in my eyes,

you need no mirrors,

to tell tales of your beauty

In my waking dreams

a haloed angel.

gives me peace

a reason to love life

THE WORLD THROUGH A PARRALAX VIEW

The Truth About The End

The flower stared right back at me

daring me to terminate its short life

I reached out to end this charade of nature

a thing of beauty cannot be forever

God's Ultimate Plan

I imagine this brilliant surrealistic splendor

of a forest becoming a nuclear wasteland

A cloud shaped like an umbrella passes over

Nineteen apostles voices try and sing in unity

The song is the same but the pitch is getting lower

all that's left is a semblance of the holy trinity

Fools, you know I do not suffer

pangs of doubt or bouts of guilt

While heretics, atheists prostrate and proffer

I push the button to end what's built

It's over and the task is done

what did not reduce to ashes, continues to burn

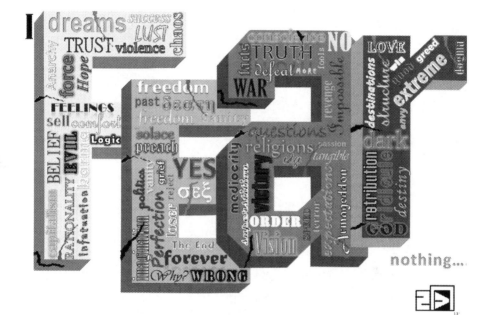

Does God Have Any Fears?

The Soul of the Square

The girl stepped up to the tunnel of death

placed a flower and cried at the sound of thunder

In a battle between truth and evil

everyone knew the odds were never even

in its finest hour of defeat

love would take its fight to the streets

cannons and artillery in the square emerged

the evil empire had all voices purged

this land is condemned to doom

this order will perish and new flowers will bloom

Lovers will wander aimlessly once again

the Lama, love and freedom will not forever be slain

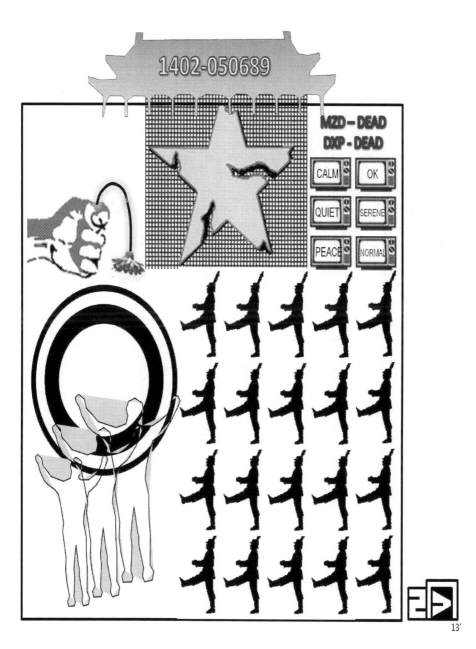

Where Fearless Dragons Once Roamed Free

The Spring of Discontent

The paid-for crowd murmured, yet dissented

unheeded messages from impeached pulpit preachers.

Inevitable troubles would be fermented

hearing denunciations from carbon dated teachers.

As litanies drift over the tribes, long tortured and tormented,

global messiahs express mock pity for the swarming creatures.

Wasted praise be on the formerly fashionable lords,

their sayings, no longer the order of breaking dawns.

Seemingly immortal infants cut their own umbilical cords,

the young unwilling to play unwitting pawns.

Slay the infidels and kaffirs with unblemished swords

Destroy coherent thought before it spawns

The kingdoms grow silent and emirs fall back into slumber

Jailors man the gallows of the prisoners ships

As blood on the ground dries, the populace grows number

And order in the land returns with stoning and whips

Choose Well

This land prides itself, on
the lack of anarchy and chaos, as
symbols of order and progress.
Attitudes stay hidden under, a
carpeted sheen of discipline, as
big brother watches, to
keep the flock from straying.
Robots occupy cribs, and
grow up to march in unison, to
a systematic piper's beats.
Should be rebels have, no
grouses against the machine, and
facebook dissent is loudest, on
the brands that matter or don't.
Will a poet ever be arrested here, for
scribbling a raging litany, on
the sides of subway cars?

My land berates itself, for
a dystopian state of flux, as
no unity of thought is achieved.

The populace is forever, on

the edge of boiling over, as

most young are restless, and

rock showers bloom everyday.

A blood soaked history, and

leaders slain as examples, to

emphasize democratic discord.

Crazed messiahs abound, and

preach sermons of love, and

occasionally of absolute truths, while

guilt ridden riches sneer, at

the untouchable sweaty poor.

A billion beliefs jostle, and

clamor to be heard, by

deaf lords on high pedestals.

Choose heaven and hell well, for

Ghalib, Caravaggio and Gaudi, meet

for coffee and conversation daily, only

amidst this strife and turmoil.

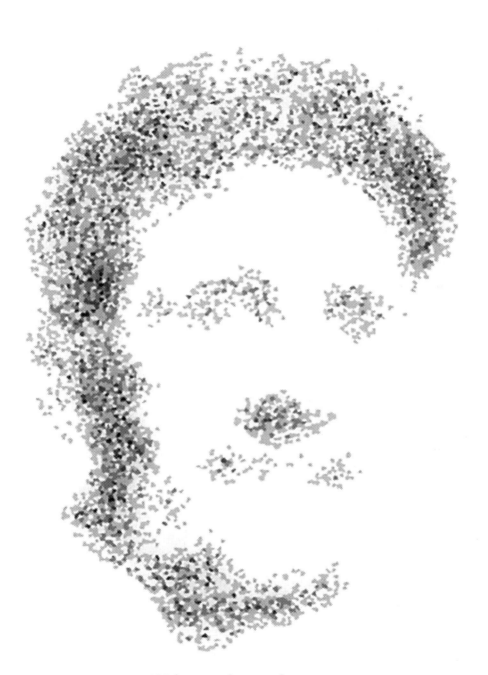

1984 - gone, but not forgotten

Women's Lib

Someone suggested that we do nothing

to raise the stakes and lose control

condemnation

damnation

revolution

Decimation....

evolution

anticipation

transformation

liberation

contribution

emancipation

Someone suggested that we do something

to raise the stakes and gain control

Ah! To Be Young In America

In 1979 at twenty one,

reached the shores

confused,

advice weary

unsure of myself

alone in America

cold, under the winter sun

brash, as only the scared can be

uncouth

persona unrefined

unrealistically idealistic

alone in America

lost, seeking the shade of a mentoring tree

eternally keen, and full of sass

irresponsible

totally unrepentant

comfortably independent

alone in America

what a fabulous time it was

Calm

I am enraptured by quiet

a child clings for comfort,
the mother sings a lullaby

sheer taste of satin,
an éclair melts on my tongue

wiggling toes, dancing,
the familiarity of old shoes

sunday morning burrowing in bed
wafting aroma of brewing coffee
the wheezing wind holds no threat,
to my grandma's patched quilt

bliss, joy, comfort, warmth
a good life should treat me such

The Floater

A floating feather,

captures my undivided attention.

which sparrow,

seeking a seed to call its own,

sheltered against the winds,

let this thing of beauty drop?

What fate lies in wait for it, I wonder.

below which head, will it form a pillow?

Or swept up with other fluff,

will it continue its journey forever?

Zoo

Dear Mr. Tiger, it hurts me too

to see you angrily pacing, behind chain fences in a zoo.

While your cousins in the forests, roam free

swim, frolic in the grass and stalk prey,

you dance to a whip, roar on the trainer's decree,

and are rewarded by chicken morsels tossed your way

Born in a pen, by human hand you were reared.

Captivity has stained your reputation, and how.

You, that should, on sight be feared,

have grown up by suckling on a sow.

In your vivid imagination, you have escaped to former glory,

from the ennui of the sheltered life you lead.

Gawking spectators and tormentors would now be the quarry.

On their fat meat, you would feed.

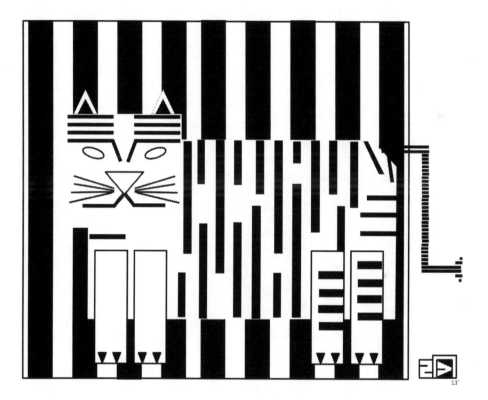

Mr. Tiger, Don't' You Wish . . .

Bombay, the Magnificient

I have walked this town's streets

looking for puzzles,

the answers for which many claim to have found

footpaths at the terminus

jammed with sellers of dreams

jostling seekers push by

the 9:06 awaits their odorous bodies

seedy bars

behind the dignified Taj

the underbelly or the definitive example

of a confused city and its people

a slum beckons

a myriad complex

lanes run like bulbous veins

joy, pain, life, death

the world goes by, nothing changed

a tableau on a single street

cosmopolitan and posh

a promotional poster beckons

housing for the rising stars

With a condescending view,

Of the urchin pissing on the road

ramparts of marine drive

obscene blocks

prevent the sea from reaching in

to cleanse the city's soul

This city is doomed

by its owners

Yet not condemned

by those who belong

My Songs

My songs do not seek to calm or pacify,

Nor convey hidden answers to anyone's prayers,

or balm for their discomforting strains.

No doubts do I attempt to clarify,

no futile attempts to peel away diseased layers,

of disused, festering socialized brains.

My words will not always attempt to rhyme,

alien are methods of laureate poet celebrities,

By Hughes, Plath and Eliot I was never smitten.

Phrases emerged incognito from my mind's grime,

limited intent to provoke liberal bleeding heart adversaries,

nor expecting emancipation through the word written.

Where go I, must my songs follow,

a truer friend one finds not even amongst dreamers.

Comforting words from others sound jaded and hollow,

my gentle songs sooth me in a world full of screamers.

Celestial Questions

Why does the cosmos keep on expanding?

Why gravitate away from the centre where you were born?

Why agree with this absolute and not keep your senses pending?

Why not attempt to stitch, from whence once you were torn?

Why must there be order in the universe?

Why should stars always align this way, not that?

Rather than fall in line, why not be diverse?

Why not agree the world's not round, but flat?

Why do brilliant suns eventually create black holes?

Why should all light and sound be trapped by density?

Why accept the obvious and not seek a reversal of roles?

Should stars get dimmer, and moons shine with intensity?

Why must the sinister night always follow a magical day?

Why should a good life, always end tragically?

Why consider it fait accompli, rather than a miraculous way?

Not the end, but regeneration, philosophically?

The Creation – A Fool Thinks Differently

A thing of wonder emerges from the mind's recesses

A toy? A totem? A twisted metaphor from my past?

Or a result of life's abuses and excesses?

In reality its an experiment to leave you aghast

Objects that strain to be defined

Dreamlike images that refuse to be confined

In colors that light up the night sky,

Built without rationales or reasons why.

Images placed in random sequences

Colors splashed in distorted spaces

Perceptions derived through fogged senses

The answers lie deep in hidden places

When is a thing, not the thing?

What happens when your mind is deceived by what you see?

Is coherent thought relevant at all times?

I know it's not you, but me.

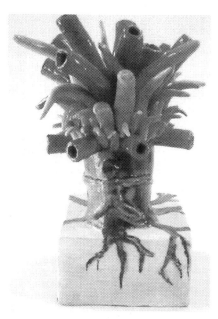

The Tree of Life

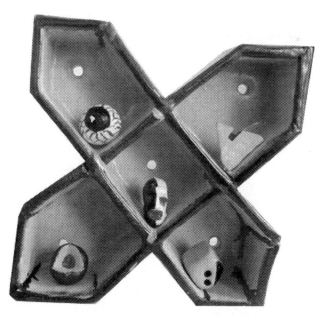

Enigma of the Unfinished Shrine

The Iconoclast Son

Rules of an ordinary life do not apply,

Judgment by a jury of peers is impossible,

When elemental logic is in great supply,

It becomes an extravagant prodigal's parable

I am my father's son, its true

In times of paradigm shifts I rise

To winds of caution, my fears I threw

Challenging powers without any disguise

Icarus I may yet prove to be in short time

Constantly seeking the heat of the sun,

Struck off the roster of life, in the prime

The heretic, destroyer of worlds, is finally undone.

The Exotic World of Quantum Mechanics

Max postulated, in a revolutionary way,

discrete quanta is how energy is absorbed and radiated.

Aha! said Albert as he shined a light on some strange materials

and on the ejecting electrons was fixated.

The fools who thought that light came to us as beams,

were confronted by photons, displaying a sense of urgency.

Neils filled them with a discrete quantum of energy,

that seemed totally dependent on their oscillating frequency.

Of a particle's energy and time, and position and momentum,

Werner was uncertain about measuring the exact value

Found it safer to explain their whereabouts probabilistically,

rather than pinpoint a location cent per centum.

It did not stop at this level of ambiguity,

for the quantum state witnessed a time evolution.

To predict the end state of a wave function, from where it started

Erwin needed to hypothesize his deterministic equation

Recent quantum theory has helped unify diverse forces,

while explaining the sub-nuclear quark's and gluon's activity.

Only Issac's gravity still eludes the unification process,

hopefully stringing along the general theory of relativity

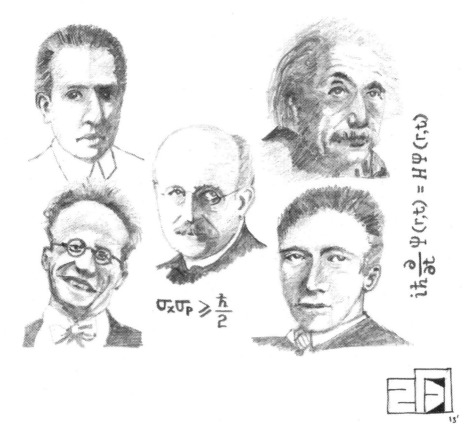

$$\sigma_x \sigma_p \geqslant \frac{\hbar}{2}$$

$$i\hbar \frac{\partial}{\partial t} \Psi(r,t) = H \Psi(r,t)$$

The Quantum Mechanists – Creators of a New Way

The Artist is Condemned

The activist distributes pamphlets on busy pavements,

extolling the virtues he holds sacred,

seeking Yudhishthra in these kalyug times.

The police van picks him up as a loiterer,

In this town, seeking justice is passé,

when charged with assorted misdemeanors and crimes.

The playwright wrangles on changes to his script,

by the producer who desperately needs a cheerful ending.

But Sir, he pleads, that was my life's tome.

The stars live happily ever after, coins jingle at the till,

while the author, drinks to his death

in his miserable city, once lovingly called home.

Glitzy romantic calendar art is all we need,

the former painter of cubist fantasia is commercially told,

if not a beatific Ganesha, then a dancing Sridevi will do fine.

He makes sure that she is drawn with a smile and oomph,

colors diluted with piss and spittle that was all his own,

then redeems his soul, hawking cheap plastic toys, from six to nine.

Poetry on the metro's crumbling walls,

declaring instantaneous freedom from capitalism,

for all who supposedly care and feel.

The poets meanwhile live in penury,

seeking alms from every passerby,

scrounging for their next meal.

MUST TRY
MY LUCK
WITH HUMOR
MY DEAR

Ode to Ogden

Must try my luck with humor

my dear

only way to exorcise the tumor

of fear

better to read some Ogden Nash

rather than your wrists, to slash

Choice of a Role Model

A battle constantly rages in my head.

to tilt at windmills like Quixote, the Don,

or to let life pass by, not look too far ahead.

to continue fighting wars that can't be won,

or to, not be a hero, and die peacefully in bed.

It's a debate that I regularly indulge in.

To be an example, with my deeds of valor,

or to squander my life in pursuit of earthly sin.

To fight in the trenches of filth and squalor,

or to end it in style with a tonic and gin.

Such be the lack of visions I carry,

please avoid all mentions of trauma and pain.

And rather than heroics I marry,

by the hand of comfort I'd rather be slain.

Damn French Mathematicians

Fourier's transformations

Lagrangian equations

Fermat, a theorem, he creates

Pascal's view initiates

an algorithm by Boole

a measure by Joule

in this mess created by Bernoulli

I feel mathematically silly

I Am Analyzed

The best psychologists in town have mapped my mind,

none revealing answers to what makes me what I am.

Opting to bury the truth, or not appear unkind

or because, for their opinions, I don't give a damn

The administration of hypnotic drugs seem badly timed,

affecting my clarity of thought in the subsequent exam.

The inserted gamma knife probe, exits from behind,

horrors! no signs of synapses firing are revealed in the scan.

Efforts to appear impotent, incompetent, deaf, dumb and blind,

have been diagnosed to be an elaborate sham.

Messages of hope, seen as convoluted ruses to have me maligned,

are forwarded automatically to the mental cavity titled spam.

Through music, not caring and logic, I now unwind

Watching bits of dark matter create an interstellar traffic jam.

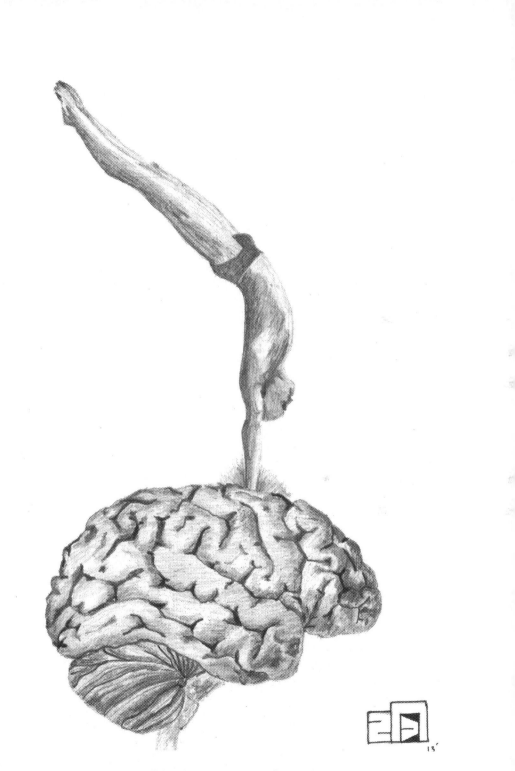

Dive Deep, Yet Tread Gently

Written in Honor of Napoleon the One Eyed Cat

Napoleon, so named, by his all things French loving, mother

At the age of one, lost half his face in an alley fracas with another

He met god, who bestowed three supernatural powers on him

Any disguise, changing shapes at will and making others do his whim

With supremacy so conferred on him,

Napoleon became the Lord of all he surveyed

All, from the high bred to the alley cats, in front of him prayed

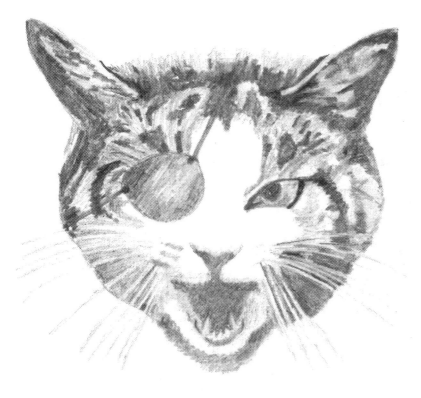

Napoleon is Not Amused

Who Have I Not Insulted Stereotypically?

The politicians, the cops, the administrators are have-been's

Since they seem to have inherited, non-performing parts of the human genes

The lawyers, accountants and doctors are epitomes of cowardice

If really that good, why takes insurance against malpractice

The bankers and other slick sales guys, you just cannot trust

Look at how wall-street survived, and everyone else went bust

Better to ignore the engineers, computer geeks and the mathematicians,

Look at any social do, the invitees list has these as obvious omissions

I have not forgotten the scientists, the astronauts and physics professors

They speak in a tongue as if perpetually tortured by Spanish inquisitors

Oh the artists, sculptors, authors and others of their kind

Debauched? perhaps, insane? likely, reputations? maligned

Why leave out the actors, musicians and editors of newspaper pages

In general their IQ's are less than half their ages

That just leaves consultants of the management type

Smart and humble, probably every penny worth the hype

An Unconcerned I

The laid back Guru tries to sell me,

An elixir that will dull my mind,

I don't mind

I don't mind

Except,

It has to be inserted from behind

The angry Author brandishes his libretto,

Convincing me of its merit for a Nobel prize

I don't care

I don't care

Except,

It's a tome that made the nausea in me rise

The corrupt politician delivers his speech,

Promises to uplift and embolden my will

I don't hear

I don't hear

Except,

It's pushed down my craw drowned in foul swill

The smirking shrink decides to probe,

Deep into the recesses of my diseased brain

I don't hurt

I don't hurt

Except,

When the lobotomized halves are sluiced down the drain

I have been lied to, carved up, looked down upon and torn asunder

I don't bother

I don't cry

I don't worry

Except...